IMAGES
of America
KUNA

IMAGES
of America

KUNA

Sharon Fisher

ARCADIA
PUBLISHING

Published by Arcadia Publishing
Charleston, South Carolina

Printed in the United States of America

Library of Congress Control Number: 2011942507

For all general information, please contact Arcadia Publishing:
Telephone 843-853-2070
Fax 843-853-0044
E-mail sales@arcadiapublishing.com
For customer service and orders:
Toll-Free 1-888-313-2665

Visit us on the Internet at www.arcadiapublishing.com

*This book is dedicated to Margaret, my own contribution to history;
see, this is what Mommy was doing all that time on the computer.*

CONTENTS

ACKNOWLEDGMENTS

In alphabetical order, thanks go to the following fine former and current citizens of Kuna who helped me with this book: Shane Baker, senior archeologist for Idaho Power, for access to early company records on the building of the Swan Falls Dam; Richard Beck of Ada County Development Services (ACDS) for access to county files; Steve Bunk, the managing editor of *Idaho*, for his kind permission to adapt my article on Kuna published in his magazine; Barbara Daniel for the pictures and information on the Kuna Kave Riding Club; Jim Duran of the Boise State University Library Special Collections & Archives for its morgue of *Idaho Statesman* photographs and its Robert Limber Collection; Aldis Garsvo and Dave Lyon of the Western Heritage Historic Byway, who provided information and photographs; Anne Hankins of the Kuna Library for access to the library's extensive collection of early Kuna photographs; Heather Hiesterman, who passed her extensive research on early Kuna to me; Carroll Ann Kimsey of the *Idaho Statesman* for its kind permission to use morgue photographs; Steve Malone, formerly of Ada County Development Services, for his historic information and PowerPoint presentations over the years; Scott and Nicola McIntosh, editor and publisher of the *Kuna-Melba News*, who recommended me for this book, for their kind permission to adapt my article on the history of Kuna that appeared in their publication *This is Kuna*, and for publicizing my efforts; Tyler Nelson for information and photographs on his father, Morley Nelson; Doug Rutan for his extensive information on Kuna schools and Kuna history in general; the Kuna School District, especially Lori Olsen and Wendy Johnson, who trusted me to unmat and scan all their Kuna school photographs; and all of the Idaho history nuts who have offered direct and indirect encouragement and support, including Curt James, the Ada County Historic Preservation Council, Sheri and John Freemuth, Todd Shallat, Cheri Cunningham, Greg Nelson, Arthur Hart, and most especially Madge Wylie; and, of course, my long-suffering Arcadia acquisitions editor, Coleen Balant. Thanks for making me look good.

INTRODUCTION

More so than many cities in the Treasure Valley, Kuna is steeped in history. While other cities have sacrificed their cores to the wrecking ball and urban renewal, much of Kuna's downtown is intact, if repurposed.

Kuna owes a great deal to geography. People settled in it based on its location near the Snake River, populated it due to mining south of the area, and built a railroad station because it was easier there than near Boise. The Snake River Canyon itself was deepened by a prehistoric flood. Even the school sports teams have a geographic connection—they are known as the Kavemen, after Kuna Cave, a lava tube south of town.

Today, Kuna is the gateway city to the Morley Nelson Snake River Birds of Prey National Conservation Area. Kuna and the surrounding area is part of the Snake River Plain that stretches for miles across southern Idaho. The vast sagebrush desert was home to Native Americans who lived on the land as hunters and gatherers.

Kuna, 18 miles southwest of Boise, now has approximately 16,000 residents. Rooted in an agricultural area, it has recently been the fastest-growing city in Idaho, tripling in population between 2000 and 2010.

Ironically, however, one factor unknown about Kuna is where it got its name. Many meanings have been attributed to the name *Kuna*, including "end of the trail" (not "end of the world," as some people joked about even 100 years ago), "green leaf," "good to smoke," "ugly," and "firewood," but no one is really sure what it means. While the "green leaf" and "good to smoke" derivations sound like modern-day jokes, they come from Charles S. Walgamott in his memoir of his adventures in the late 1800s in southern Idaho, entitled *Six Decades Back*; he cited the origin of the name as a Shoshone Indian word. *Idaho Statesman* editor Milt Kelly once called it "the ugliest, nonsensical name that could be picked out for a railway station."

Years after its original settlement in the 19th century as a railroad depot to support mining operations at then booming Silver City, all that remains is a signboard with the name Kuna and a graveyard. The cemetery is located near the original route of the Silver Trail along Stagecoach Road. It is now known as Pioneer Cemetery.

In 1961, the Kuna Grange undertook the task of restoring the Pioneer Cemetery. Weeds and debris were raked and hauled away. Loads of dirt were pushed into a mound over each grave. Cinder rocks were installed to make an outline for each place and a larger rock set for a headstone. Native flowering cacti were planted on each mound. A sign was made with all the names of the pioneers interred there. The list of names was stamped on aluminum sheets and attached to the sign. The Kuna Grange makes this care an annual project and keeps the cemetery clear of weeds and provides flowers for Memorial Day.

Some early settlers built shacks of basalt to live in, because there was no wood or even sod for houses. The land was covered with sagebrush, which pioneers grubbed from the fields and then burned for fuel. Sometimes they even built with it.

The town was reborn in the early days of the 20th century due to the promise of irrigation. By late 1908, the population of Kuna was approximately 75. On October 25, 1909, Kuna Evan Havard Hodkinson was the first child to be born in Kuna, in the first building erected in the community. By 1910, the population was 300.

On April 21, 1910, State Master D.C. Mullen met with some 15 or 20 farmers for the purpose of organizing a Grange at Kuna. On May 2, 1910, the organization was completed. A charter was issued by the national organization on May 11 to Kuna Grange No. 59, which makes the Kuna Grange the second-oldest in the state. The Grange was the first fraternal order to get a charter in Kuna and was instrumental in promoting agriculture and various improvements, including cooperative buying. In the days before easy transportation and chain businesses, this plan of banding

together was a big help to farmers and may have been the forerunner of later cooperatives. Coal was purchased by the railcar load, and apples and alfalfa seed shipped by rail to various central markets. The Grange was also instrumental in procuring an Oregon Short Line depot and agent in February 1911 and vigorously protested its closure several years later.

However, the Kuna Grange was not all business. It was not uncommon for sessions to last until 4:00 a.m. One entry in the secretary's book, dated August 3, 1912, tells about the younger members arriving at seven minutes past 1:00 a.m. and asking to be counted present. Their request was granted, "inasmuch as Grange did not open until 11:00 p.m.," but it was decided at that meeting that, in the future, no one arriving after midnight would be counted present "unless over 70 years of age." The secretary's minutes refer to ice cream socials, oyster suppers, picnics on the Snake River, and, in September 1912, an excursion to Arrowrock Dam in Boise over Labor Day weekend. Considering the fact that cars were still pretty much of a novelty in those days, the Grangers really got around.

In 1916, Kuna Grange was the second largest in the state, with 134 members, while in 1919, it had 140 members, making it the largest Grange in Idaho. Nearly every farmer in the vicinity of Kuna was a Granger. Kuna Grange has produced a number of state and national Grange officers. At times, it has been the largest Grange in the state of Idaho. It is now one of just two Grange chapters in Ada County.

Farmers also had to deal with hordes of jackrabbits that ate their crops, as well as other varmints, such as coyotes and weasels—with them burrowing under fences by the thousands. Mass hunts were organized to eliminate the pests. One settler tells of the big rabbit drive of the spring of 1910, when an estimated 6,000 rabbits were killed. The settlers decided that something had to be done about the rabbits if they were to have any crops left at harvest time. They invited the gun clubs of Boise, Meridian, and Nampa to help them reduce the rabbit population. A total of $8 was solicited from residents of the three towns to buy food for the hunters. Dead rabbits were sold for meat by the wagonload. For entertainment, townspeople would also walk together down the railroad tracks counting jackrabbits. There was no commercial entertainment in Kuna, and transportation was still mainly by horse and buggy, so any recreation was necessarily homemade, including street carnivals, picnics, contests, and debates.

Meanwhile, Kuna was now developing as a fruit-growing center. Nampa Apple Orchard Company was incorporated in 1911. The shareholders acquired 240 acres southwest of town. The land was platted as the Kuna Orchard Tracts, and three commercial varieties of apples were planted.

On April 14, 1914, the Kuna Cemetery Club was founded. It was organized to raise money to purchase a site for a cemetery for the community. To bury the dead, residents had to make a long trip by buggy or wagon to Nampa, then take the train to Boise, and repeat the procedure in reverse to return home. After taking the trip to Boise to bury her uncle, Mattie Ferguson stopped by the Boise Post Office and bought a supply of penny postcards. The postcards were sent to every woman in Kuna, inviting them to her home to discuss the need for a cemetery in Kuna.

The club incorporated as the Kuna Non-Sectarian Cemetery Association and raised money to buy 10 acres of land, which it then sold to local families at the rate of four lots for $20. Buying the land and improving the cemetery took several years. The cemetery was first called the Fairview Cemetery. When it was accomplished, the club turned its project over to an organized cemetery district. The first two adults were buried in the Kuna cemetery in 1915—Jerome Ferguson, who died January 29, and Ella Smith, who died January 30.

Kuna's first regular newspaper, the *Kuna Herald*, went to press on November 19, 1914, with Charles H. Shepherd as editor and publisher. The first issue was four pages of six columns, but only one issue went out that size. The paper had to be enlarged to seven columns and four pages because of the liberal advertising patronage. Within one year, the paper was enlarged to an eight-page, six-column paper. The *Kuna Herald* was one successor to the *Kuna Store News*, which was printed by the business firms of the town and which served as an advertising medium as well as containing local news items.

Kuna was incorporated on September 13, 1915, in the middle of a prosperous decade of land development brought on by the opening of the New York Canal (NYC). At that time, the townsite covered some 540 acres, had a population of 227, and had an assessed valuation of $268,744.

After the cemetery was turned over to the cemetery district, the Kuna Cemetery Club changed its name to the Kuna Improvement Club, a social and civic club, in 1916 and sought different projects in the community. One of the first projects of the new club was a clubhouse and meeting place for residents, as there was no school auditorium at that time. The women bought the lots at the corner of Fourth and D Streets from town founders D.R. Hubbard and F.H. Teed in 1920 for $300, paying $200 down with the other $100 due in one year, interest free.

Federal relief programs created by the 1933 New Deal helped to put men back to work during the Great Depression. In Kuna, this helped create the city's sewer system.

Until the 1960s, what was then the village of Kuna operated under a board of trustees and a chairman. The following is a list of trustee chairmen:

September 15, 1919, A.H. Christenson

May 1, 1919, Victor Carlson, chairman

May 8, 1922, Franklin B. Fiss, chairman

May 5, 1931, B.J. Leonard, chairman

May 2, 1933, H. Bernard Matthews

May 7, 1935, H.C. Sims

May 1, 1939, H. Bernard Matthews

May 4, 1959, Norman E. Covert, chairman

May 1, 1961, J.M. Smith, chairman

January 7, 1964, Lawrence Hayes, chairman

In 1968, the village of Kuna was incorporated as a city and went to a mayoral form of government. The following is a list of the city's mayors:

September 5, 1967, Lawrence Hayes

January 2, 1968, Mary Pride

January 10, 1972, Charles Bird

January 6, 1976, Duane Yamamoto

January 8, 1980, Maxine Kramer

April 6, 1982, Robert G. Faddis

January 3, 1984, Willard G. Nelson

January 12, 2004, O. Dean Obray

April 25, 2007, J. Scott Dowdy

January 3, 2012, Willard G. Nelson

Kuna continued as an agricultural community after World War II and grew slowly, as it was considered to be far away in the country. As recently as the 1970s, some major roads in Kuna were still dirt. The building of Interstate 84 in the 1960s and 1970s brought more people to Kuna, as did the widening of State Highway 69 in the late 1990s. That, combined with rising land and home prices in the rest of Ada County, began bringing even more people to Kuna, fueling its rapid growth. In 1990, Kuna had 1,955 people, and grew to 5,222 by 1999, 8,839 by 2003, and almost 13,000 by 2007.

A good way to explore the history and geography of the Kuna area is through the Western Heritage Historic Byway, which is both a state and a national scenic byway. The 47-mile byway starts in Kuna and includes historic points such as the Kuna Grange and the Pioneer Cemetery.

Some of the byway follows the Snake River Canyon, reaching from Yellowstone National Park in Wyoming to the Columbia River. It was created by volcanic activity as much as 17 million years ago. A natural dam formed Lake Bonneville, a glacial lake in the Salt Lake area, larger in size than Lake Michigan and more than 1,000 feet deeper than the Great Salt Lake. About 15,000 years ago, this dam failed, releasing a torrent of water that reshaped the entire canyon. Water from the lake flowed north and west into the Snake River Plain and Snake River Canyon. This flood carved the Snake River Canyon deeper and deposited sediments and debris along the way.

Another spot along the byway is Initial Point, a volcanic butte rising from the western Snake River Plain. Beginning on April 19, 1867, surveyors mapped the entire state starting from this butte. Every piece of land in the state is referenced by its direction and distance from a brass survey marker on top of the butte.

A walking tour of the Kuna downtown, showing the location of a number of historic buildings and residences, is available from the Ada County Historic Preservation website. Several buildings, including some Craftsman houses, have been named as "Ada County Treasures" for their historic value. Wander through Kuna—and walk into history.

One

THE ROAD TO SILVER CITY

While part of the Oregon Trail followed the Boise River to the Snake River and brought settlers to the area later known as Kuna as early as the 1840s, its hot, dry, dusty climate discouraged many pioneers from settling in the area.

In 1862, silver and gold ore were discovered in the Owyhee Mountains to the south, resulting in a boomtown called Silver City and a trail toward it from Fort Boise.

In 1881, when the Oregon Short Line Railway Company started building its line westward across Idaho, it bypassed Boise City due to the uneven terrain and instead, in 1882, established a construction and materials camp at Fifteen Mile House stage station because the Silver City road crossed the railway right-of-way there. Weather, accidents, and violence reportedly killed nine men, followed by a diphtheria epidemic that killed 11 children.

When the line was put into operation in September 1883, a station was placed at that point, called "Kuna." A settlement grew up around the station and flourished. From 1883 to 1887, supplies for Boise City, Idaho City, Placerville, Centerville, and Silver City were transported by freight wagon from the railroad at Kuna. Hauling goods and passengers to Boise became an important local industry. The early town consisted of at least three warehouses, a depot, and a post office, established in 1884.

But Kuna's early settlement was short-lived; after the branch line from Nampa to Boise was completed in 1887, the need for a depot at Kuna was over, and the depot itself was shut down on September 18, 1887. The settlement closed down, and Kuna became just another railroad siding where the trains would replenish supplies such as water and wood.

The stage road started near the Oregon Trail near Boise's western bench, then stretched southwest across the valley to present-day Kuna Butte. The stage then crossed the Snake River at Walter's Ferry in Owyhee County. At least two stage stations developed along the route. One site was originally known as Fifteen Mile Station because it was 15 miles southwest of Boise and approximately 20 miles from the Snake River. In what became the Kuna area, the Silver City Trail was a broad, well-defined, deeply worn wagon road. It crossed the railroad at the foot of Cemetery Hill and angled directly northeast and southwest. Extensive research by the Owyhee County Historical Society, which found three separate maps (each showing part of the trail between the nearby town of Mora and Silver City), allowed the organization to piece together the route of the trail by overlaying the maps. (Idaho State Historical Society [ISHS] 76-119.4.)

This stone house (above), now in ruins, was used in the 1860s by early miners. It includes a chimney that may have been used to help assay gold. Prospectors built houses out of stone because, after the gold rush, any wood around the area was gone within six months. The Fifteen Mile House was a stopping place on the old stagecoach road to Silver City and Winnemucca where travelers headed to and from Boise stopped. There was so much activity at Kuna that it was considered the settlement that could be the successor to Kelton, Utah (below), another supply town farther south. (Above, Historic American Engineering Record [HAER], Library of Congress; below, ISHS 73-66.1, Stage Station, Kelton, Utah.)

Silver City is pictured then and now—both in its heyday in the early days of the 20th century and in a more recent photograph documenting the region. Silver City is considered one of the finest ghost towns in southwestern Idaho, but the term "ghost town" is really a misnomer, as people still own houses and live in the area, at least during the summer. Founded in 1864 after gold was discovered in Owyhee County, it became the county seat in 1866, though it lost the title to Murphy in 1934 after mining declined. By 1866, the population of the area was about 5,000. (Above, ISHS 60-120.9; below, HAER.)

The Kuna area was essentially abandoned until 1904, when D.R. Hubbard and F.H. Teed planned a community on the land they had homesteaded. At that time, Kuna was represented by a signboard near the railroad track inscribed with the word "Kuna" and a small shed on the right-of-way, erected by Hubbard, for the storage of grain for his construction camp on the New York Canal work. After the filing, the railroad even approached Hubbard and Teed about building a station there again. In August 1907, the organized townsite of Kuna was platted, lots were auctioned off, and a new depot eventually put the town back on the mainline. A permanent train depot was built in 1913—replacing an old boxcar used as a waiting room that had gradually been torn apart for firewood by people waiting for trains—as well as a station house. (ACDS, but originally ISHS 81-87.1)

In 1883, the Oregon Short Line Railroad reached the old Fifteen Mile Stage Station. The tracks were extended to Nampa. The first passenger train over the western section of the Oregon Short Line reached Kuna at 11:40 a.m. on Tuesday, September 25, 1883. Eight of the nine passengers aboard got off and went to Boise on the stagecoach. The Oregon Short Line Railway was organized in 1881 as a subsidiary of Union Pacific Railway. Union Pacific intended the line to be the shortest route ("the short line") from Wyoming to Oregon. (Both, ACDS, but originally ISHS 64-44.3 and 66-15.10.)

Kuna grew with the railroad station providing business. According to an April 1884 *Idaho Statesman*, "Teamsters coming in after freight for Silver City and Boise, the hands employed on the railroad, and the arrival and departure of stages and trains give a lively appearance and considerable business. Mr. Huff, who has been engaged in running a feed stable and corral, and a saloon, has sold out the former and says he is doing a very good saloon business." The pictures show Oregon Short Line engines. (Both, ACDS, but originally ISHS 73-80.4 and 75-232.8)

According to the Historic American Engineering Record, the Phillips Mine was located by Jacobs Gulch miner John F. Sullivan and Isaac Phillips in May 1887. In January 1888, they were extracting enough metals to keep a mill running, which was about "5 bars of bullion valued at over $11,000 as a result of the first run." In February 1890, it was reported that "the lode got larger and richer the deeper it went into the mountain"—about $100 to $300 per ton, which was a considerable increase from 1888 when it was $32. In June, 80 tons were taken to the mill for processing. The mine continued to produce steadily into 1892. Phillips and Sullivan took regular shipments of ore from the mine through 1893 and 1894. However, in 1895, they dissolved their partnership. The mine was demolished in the mid-1990s. (HAER.)

Two

Illuminating the Desert

Located on the Snake River Canyon is the cradle of Idaho's hydropower industry, Swan Falls Dam. Built in 1901 to provide electricity to the Silver City mines after they ran out of wood for fuel, the dam still provides electricity today, though the powerhouse was rebuilt in the 1990s. Swan Falls is thought to be named after a prospector named P.M. Swan, who filed for a placer mine near the rapids in 1892.

The three-phase electricity used by the dam was the testing ground for modern electricity. In those days, Thomas Edison was a proponent of direct current, while Nikola Tesla was an advocate of alternating current (AC); AC was better able to traverse the distance between the dam and Silver City.

A new concrete dam replaced the wooden crib in 1920, and in 1936, the rocky outcrop on the east side of the river was excavated for an additional spillway and 10 new gates. The dam is 1,150 feet across and 107 feet high, with a surface area of 1,525 acres, and the reservoir catchment area covers 41,900 square miles.

In what is an interesting bit of symbolism, the plant was built in the Romanesque style, which is also often used for churches. As for Silver City, it continued to receive power until the 1930s, when the system was shut down so the equipment could be repurposed. Today, Silver City residents use solar power.

After the Swan Falls powerhouse was rebuilt, the old powerhouse was turned into a museum to celebrate its history, including pictures of the old powerhouse and the new powerhouse being built, equipment from the powerhouse, explanations of how electricity works, and vintage advertisements encouraging farmers and farmwives to use the new, clean electricity.

In the wake of 9/11, access to the powerhouse was restricted as a security risk, but the museum with its surrounding area, which is in the National Register of Historic Places, has a popular open house in May during Idaho Archeology and Historic Preservation Month and by appointment during the year.

The massive turbines for the first Swan Falls Dam electrical-power project in 1901 had to be hauled miles down a steep and rocky incline, drawn by horse and wagon. The original powerhouse contained four vertical turbines produced by S. Morgan Smith Company of York, Pennsylvania, and three Westinghouse generators, which produced 300 kilowatts. (ACDS.)

The Snake River and the Swan Falls area provided more than electrical power. Until irrigation, water for stock and human consumption had to be hauled in barrels from the Snake River, more than 15 miles away. Residents, as well as workers on the Swan Falls Dam project, also fished for sturgeon and other large fish from the Snake. (Kuna Library.)

This is a 1911 view of the Swan Falls residential buildings. From left to right, the residential buildings are cottage No. 101, the cottage that burned in 1921, and the clubhouse, which was used as a boardinghouse for single men. The other buildings in the foreground are storehouses and shops. (Historic American Buildings Survey [HABS], Library of Congress.)

Taken around 1920, this is a view of cottage No. 101, which later burned, and the Swan Falls Power Plant and Dam. Because of the site's remote location, residential facilities were required both for construction workers and, later, for plant employees. (HABS.)

This is an early view of the Swan Falls Dam area. Note that, in this photograph, there is only one powerhouse, which makes it possible to date this picture as being taken between 1901 but before 1907 when the second powerhouse was built. (ISHS 73-51-21_c., but originally from HAER.)

This is a view of the Swan Falls dam and village. When mining activity declined, power was extended north. One use for the dam's power was to supply electricity for Boise's interurban trolley lines being built to serve rural areas. Ironically, though the Kuna area supplied power for the trolley, the interurban did not serve the Kuna area. (HABS.)

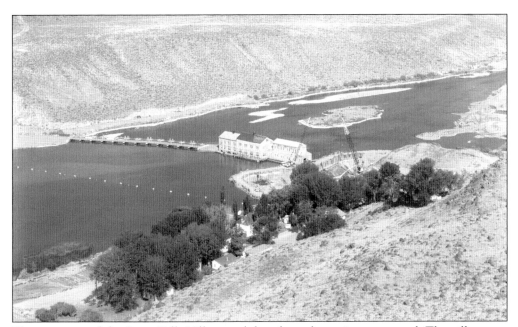

This is a view of the Swan Falls Village and dam from the main access road. The village was continuously occupied from the early 20th century until the early 1990s, at which point new cottages were constructed for the workers further away from the dam because of increased recreational use in the area. (HABS.)

This is a view of the Swan Falls Dam and village. The following village structures are visible on the hillside, from left to right: cottage no. 521, garage No. 531, and cottage No. 101. The following village structures are visible at river level, from left to right: cottages Nos. 361–363, boathouse No. 394, clubhouse oil, garage No. 393, cottages Nos. 191 and 181, and garage No. 532. (HABS.)

This is a view taken of the village, dam, and powerhouse around 1945. The clubhouse is at the lower left, with cottages Nos. 361–363 to the right of it on the same side of the road. Cottage No. 231 shows washing on the clothesline. Cottage No. 101 is located at the lower right. (HABS.)

The Swan Falls Dam was the first of 17 dams to be built on the Snake River and its tributaries and was one of the earliest built in the Pacific Northwest. It was originally built by Trade Dollar Consolidated, a Silver City mining consortium, to provide the first electric power to the gold and silver mines in the Owyhee Mountains. (HAER.)

This is a view of the powerhouse, showing all three sections. They were originally designed by Andrew J. Wiley, an irrigation engineer and assistant of engineer Arthur D. Foote. Trade Dollar wholesaled power to distributors. In 1910, the Trade Dollar investors organized the Swan Falls Power Co. and added two new generators. (HAER.)

This is a view of the powerhouse from downstream. Idaho Power acquired Swan Falls in 1916 during a major consolidation of southern Idaho power companies in receivership, expanded the capacity of the dam, and added new equipment in two phases. At that time, the dam had the largest generating capacity in the state. (HAER.)

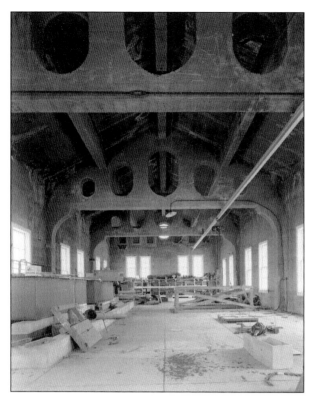

This is an interior view of the concrete roof structure in the attic of the 1907 section of the powerhouse. The interior of the building is painted, although the second floor shows the bare concrete walls. Supporting the roof are three reinforced concrete trusses. Windows provide light and air. (HAER.)

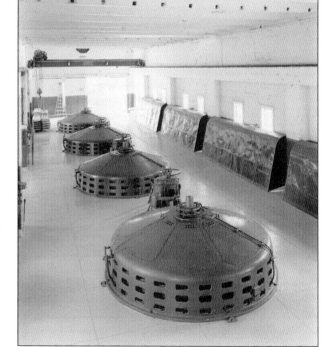

This is an interior overview of the 1907 section of the powerhouse. It was used as a training assignment for new engineers in the Idaho Power Company system because of the variety of manually operated equipment at this site, including generators installed in 1918. (HAER.)

This is a view of the control panels and the control room in the 1910 section of the powerhouse. The original powerhouse consisted of three separate but attached buildings—one constructed in 1900, then one in 1906, then one in 1910, after which the original was replaced in 1911–1913. All three buildings, made of poured concrete, still exist today. (HAER.)

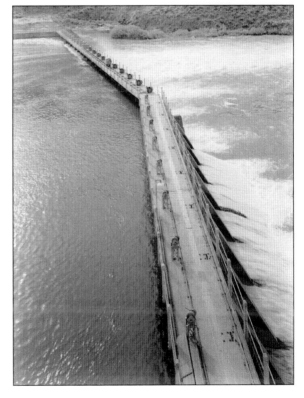

This is a view showing the top of the spillway. New spillways were built in 1914, along with two additional turbines and generators. In 1919, Idaho Power began to rebuild the old wooden spillway dam between the lava island and the left shore. (HAER.)

This view of the spillway shows its wooden gates and concrete. Because the dam's water rights were never subordinated to those of future irrigation projects upstream, Swan Falls was the focus of water use and water rights conflict during the 1970s and 1980s, the resolution of which altered the course of economic development and water use in southern Idaho. (HAER.)

This is a view of the concrete fish ladder intended for salmon. It was placed in operation on September 17, 1922, after complaints about the original, though it had been "the best ladder that the U.S. Fish Commission recommended." The Historic American Engineering Record report states that "this fish ladder is still in place, but present operators do not recall it ever being in use." (HAER.)

"Flowering shrubs, vegetable and rose gardens, grape arbors, pasture or animal enclosures, a fruit orchard, a children's play ground, clothes lines, outdoor fireplaces for barbecue, small sheds, and other signs of domestic use and enjoyment characterize the environs of the village," notes the Historic American Buildings Survey (HABS) report. The company built residential cottages to accommodate married employees and families. (HABS.)

This view of the kitchen of cottage No. 101, built in 1910, shows the living room is on the right, with a view into the hallway and front bedroom. Remodeling the cottage in 1955 cost $2,066. This remodel was needed, in the opinion of the superintendent, because the kitchen is "so small as to be entirely inadequate,'" the HABS report states. (HABS.)

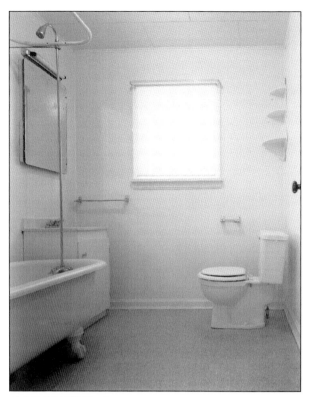

The building, located higher than the others and with a view of the canyon, eventually housed the chief operator and became known as the "Chief Operator's Cottage." The remodel of this and other cottages in the 1950s was part of a larger postwar reconstruction program at Idaho Power facilities. The lion's-foot tub may date from the original building. (HABS.)

This is cottage No. 191, which was built in 1919 as indicated by the number. The kitchen was remodeled in 1950. This cottage and cottage No. 181 represented the first major residential facility added to the village by Idaho Power after it was created from the merger of the predecessor companies. (HABS.)

This is an interior view of cottage No. 231, which (by its number) was built in 1923. It was also known as the "Superintendent's Cottage" and was larger and more elaborate. This picture shows the living room, dining room, and kitchen from the front doorway. It is one of two remaining cottages on the site. (HABS.)

This is a view of the kitchen in cottage No. 361, which (by its number) was built in 1936. Cottages were designed by Idaho Power engineers (rather than architects), who used material from magazines like *Architectural Record*, *Building News*, *Ladies' Home Journal*, and *Architectural Forum* for ideas. (HABS.)

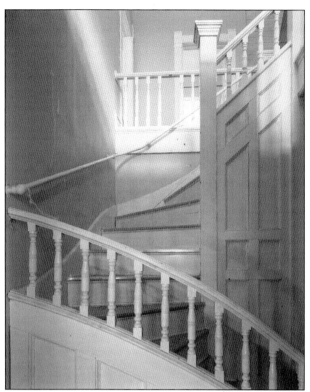

The clubhouse was built in 1901 to house the permanent operating crew at Swan Falls Dam. This building was occupied by single men working at the power plant. It was run by a cook and manager hired by Idaho Power on contract. The building was upgraded periodically. (HABS.)

This is a clubhouse bedroom. Heating was originally supplied by coal furnaces, but they were phased out not long after 1936 for electric resistance space heaters manufactured by Swan Falls employees. The superintendent wrote that they were "a much better and safer all around heater than can be found on the open market." One is shown on the table. (HABS.)

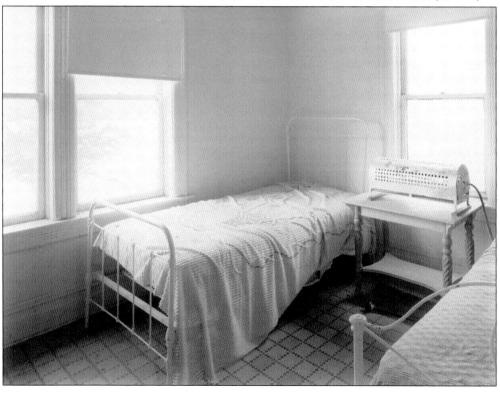

Morlan Nelson, known as Morley, was born in 1916 and was a fan and an advocate for raptors all his life. He starred in and developed seven wildlife films for Walt Disney, as well as others for PBS and other networks. He is shown here with his wife, Betty Anne. (Aldis Garsvo, but originally from Tyler Nelson.)

The Snake River Canyon supports one of the world's densest concentrations of nesting birds of prey. In the 1940s, scientists discovered more than 1,000 pairs. More than 20 species reside here—16 of them nesting and eight migrating or wintering. From March through June, sightseeing and nature-study groups attract visitors. (Aldis Garsvo, but originally from Tyler Nelson.)

Nelson worked with Idaho Power and Edison Electric to modify power line designs to prevent the electrocution of raptors, which resulted in similar safety efforts nationally and internationally by other utility agencies. He also persuaded Cecil Andrus, former Idaho governor and then interior secretary to Pres. Jimmy Carter, to protect the area, managed by the Bureau of Land Management. (Aldis Garsvo, but originally from Tyler Nelson.)

In 1993, then US Representative Larry LaRocco (Democrat, Idaho) led the effort to help protect the region's unique environment. Later that year, it was named as the Snake River Birds of Prey National Conservation Area (NCA), spanning 600,000 acres. Nelson died in 2005, and the NCA was named after him in 2009. (Aldis Garsvo, but originally from Tyler Nelson.)

Three

THE MIRACLE
OF IRRIGATION

It took the promise of water, through the engineering marvel of irrigation, to bring life to the region. When the US Reclamation Service was established in 1902, planned project sites included the Boise Valley. Major reservoir development began on the Boise Project, including expansion of the New York Canal system. Eventually, it ran south of Boise to the Kuna area and extended onto Deer Flat Reservoir near Nampa.

What became the town of Kuna might have remained on the site of the railroad camp had it not been for lack of water. The first man-made attempt to get water was an 18-foot well, dug in the bed of Indian Creek, which is dry most of the year, near Mora.

Major reservoir development began in 1906 and included building Diversion Dam, southwestward expansion of the New York Canal system, and construction of Deer Flat Reservoir (first known as Lake Lowell) near Caldwell.

The New York Canal was constructed in three segments. This 1908 control structure, dubbed the Callopy Gates, marks the beginning of the western third of the canal, from Indian Creek to Lake Lowell. The purpose of the structure was to allow for emergency water shut-off, but this has never been necessary. With the gates shut, water is diverted directly into Indian Creek via a spillway upstream of the structure. The name "Callopy" (sometimes spelled Collopy) comes from a former Oregon Short Line Railroad siding nearby that was named for an employee of the railroad. While the siding no longer exists, its proximity to Indian Creek farms allowed early farmers to more easily transport their produce to distant markets. It is also interesting to note that Columbia Road was originally called Callopy Lane.

On February 22, 1909, the first water was let into the New York Canal at Diversion Dam east of Boise. Irrigation water was now available to the Kuna region. Soon, 50,000 acres were developed and under irrigation. Homesteaders who had misestimated the eventual placement of canals literally found themselves high and dry and generally moved on.

When people first moved to the Kuna area, this is what most of the land looked like: a sagebrush desert, which had to be grubbed out before the land could grow crops. However, resourceful residents soon found numerous ways to make use of sagebrush, ranging from firewood to actually building shelters out of it. But they looked forward to irrigation to make agriculture easier. As Hazel Teed Painter, daughter of one of Kuna's founders, recalled, "During the summer months, dad would burn the sagebrush to clear the land, that being easier in spite of the heat than grubbing it out bush by bush. When we moved out to Kuna, a family nearby was living in a tent. The mother and kids would chop sagebrush into stove-wood lengths, haul it to Meridian, and sell it for two dollars a load." (ISHS 2060-77.6.)

When the US Reclamation Service was established in 1902, its planned project sites included the Boise Valley. The initial authorization of the Payette-Boise Project (the name was changed to Boise Project in 1911) was made on March 27, 1905, with an allocation from the secretary of the interior of $1,300,000 for construction under provisions of the Reclamation Act of 1902. The approved plan called for the construction of a dam on the Boise River to divert water into a canal that would transport it to Indian Creek. The water would then travel down Indian Creek for a short distance before being diverted into a second canal and transported to a storage reservoir, which would be constructed at Deer Flat. Major reservoir development began on the Boise Project, including expansion of the New York Canal system. This is the New York Canal Deflecting Dam, taken on October 3, 1906. (ISHS 61-165.1)

Advertisements for bids for construction of the diversion dam, main canal, Deer Flat Embankments, and associated structures were published in December 1905. Bids were opened on February 1, 1906. The contract for construction of the Boise River Diversion Dam was awarded to the Utah Fireproofing Company of Salt Lake City for $58,950. This picture is from the opening day of Diversion Dam, and the caption reads "Crowd returning from opening of headgate at government dam, Boise, February 22nd, 1909." Over 35,000 areas of desert land were made available as irrigated farmland—more than was available to all of the towns in Boise Valley combined. So, here was Kuna, the nearest trading point for the Ten Mile Settlement and the Kuna Butte Settlement, 10 miles from any competing town, and on the main line of a great railway system. D.R. Hubbard predicted that Kuna could grow to 4,000 to 6,000 people. (ISHS 74-91.47)

This picture shows the Diversion Dam shortly after its completion on November 22, 1908. *The Boise Project*, written by William Joe Simonds in 1997 for the Bureau of Reclamation History Program, states the following: "By April 16, 1907, the date specified for completion of the dam, the project was only 41% complete. High water again delayed work in December 1907, February and March 1908, and from April through June 1908. In January 1908, the sixteenth superintendent of construction for the contractor took charge of the project, and by the time the dam was completed, at least nineteen different superintendents had supervised construction for the contractor. The dam and diversion works were completed on October 10, 1908. Delays and cost overruns amounted to a loss by the Utah Fireproofing Company of over $90,000." (ACDS, but originally HAER.)

These pictures show the New York Canal headgates on November 22, 1908, and the Diversion Dam in operation, shortly after its opening, on April 11, 1909. The picture shows about four feet of water in the canal and about the same amount going over the spillway. The following is how Catherine Franklin described Kuna: "There was no water in the vicinity. The atmosphere was so dry that not even dew fell. Wet clothes hung out at 9 o'clock in the evening would be dry in 15 minutes. There were no sounds at night except the howl of a lonely coyote now and then. There were no birds nor insects, not even frogs, until the water came." (Both, ACDS, but originally HAER.)

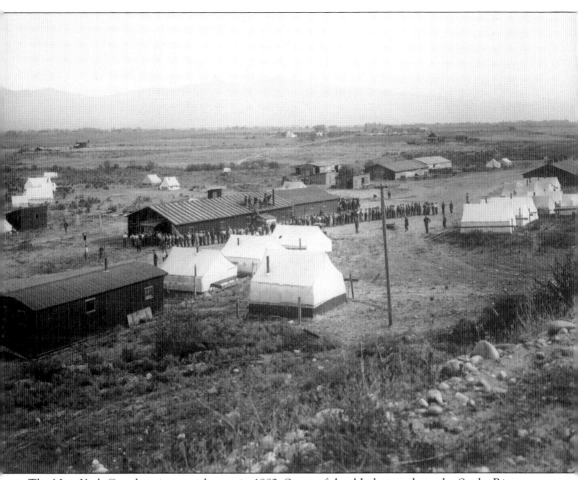

The New York Canal project was begun in 1882. Successful gold placers along the Snake River, as well as reclamation prospects, caused some New York investors to plan a massive reclamation project leading from the Boise River. These investors hoped to cover the cost of the canal through placer-gold production. Not only would the canal's water feed new farmlands but also could be used during the summer months to work the Snake River placers. Bank failures delayed the canal project, and an alternative source of irrigation for the project was sought. The Phyllis Canal, begun in 1886, served a portion of the New York Canal system. Further bank failures and litigation over water rights prevented the original canal's completion until the 1900s. This picture shows a New York Canal laborers' camp on October 24, 1910. (ACDS, but originally HAER.)

In 1902, the US Reclamation Project was founded to provide money for irrigation projects. The Boise Project extended the New York Canal, shown here on October 24, 1910, to Kuna. Hazel Teed Painter described the general situation as follows: "In the early days of settlement in Kuna, settlers grubbed and burned the sagebrush, leveled the land, and planted their seeds. Crops, however, were destined to dry up for several years as the ditches invariably broke and the seeding was lost. It was only after the Reclamation Service took over and enlarged the ditches and finished them properly, which the old New York Canal Company had not had the money to do, that an adequate and dependable water supply was had." (Above, ACDS, but originally HAER; below, ACDS.)

Widening of the New York Canal was performed both by hand and by horse, as shown above, and by machinery such as this steam-powered dragline, as shown in the picture below, which was taken on October 24, 1910. When the widening project was finally completed, the New York Canal from the Boise River to Deer Flat was 40 miles long. The original canal, constructed in the late 1800s, had a capacity of about 200 cubic feet per second, which was increased to 1,500 cubic feet per second by the Reclamation Service. The modified canal had a bottom width of 40 feet with water running at a depth of about eight feet. (Above, ACDS, but originally ISHS 69 25.4; below, HAER.)

The photograph above of the widening of the New York Canal shows workmen lining the main canal just below the dam at Boise Canyon. This picture was taken on October 22, 1910. Taken on October 24, 1910, the photograph below shows workmen preparing for lining the main canal, looking from the lined section to the unlined section. Today, the Boise Project supplies water to approximately 224,000 acres of land, plus a supplemental water supply to about 173,000 acres. (Both, ACDS, but originally HAER.)

Arthur D. Foote arrived in 1884 to design a 75-mile-long canal to expand irrigation. However, due to a lack of money, it took more than 25 years to finish. The above picture shows the structure that controls the movement of water into the New York Canal, while the picture below shows the Indian Creek control structure, which is what allowed irrigation water from the New York Canal to enter Indian Creek and from there take it to the Kuna area. (Both, ACDS, but originally ISHS 2507 and 61-165.19.)

The Boise Project, written by William Joe Simonds, states that "in addition to the modifications to the existing New York Canal, reclamation constructed miles of new distribution canals and laterals and enlarged and modified many miles of existing canals and laterals. Work on the distribution and lateral system began in 1908 with most of the excavation being carried out by contract while Reclamation forces constructed control works and structures. Much of the excavation for laterals was done under a cooperative agreement between the Payette-Boise Water Users Association and Reclamation. The water users association contracted with the settlers to construct the lateral system under the supervision of Reclamation, with payment for the work being made with certificates that could be redeemed by Reclamation for payment of water charges. The majority of the system was completed by the end of 1910." (ACDS, but originally ISHS 75-40.3.)

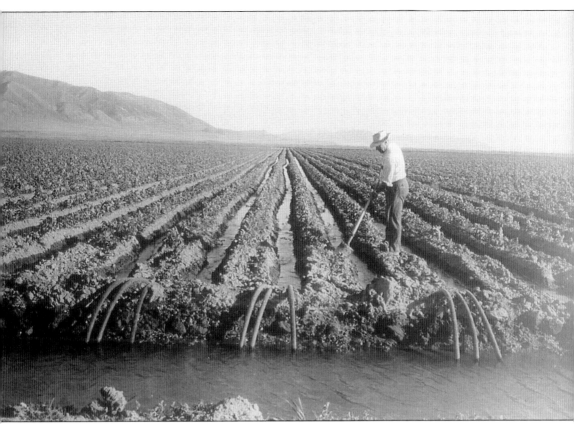

Before irrigation, farming was a challenge in the arid area, although the soil was fertile. Hazel Teed Painter, daughter of one of the founders, stated, "To prepare land for cultivation in Kuna, we were told by old settlers that all that was needed was to grub or burn the sagebrush, drag a leveler, which was a frame constructed of heavy planks over the land, survey and plow ditches along the high ground, and seed it. We found, the hard way, that the land could never be irrigated with any success without a great deal more work than that. It had to be plowed, harrowed, and leveled much more carefully and smoothly than in parts of the country where rain furnished the moisture." Irrigation made the process much easier. (ACDS, but originally ISHS 65-41.2.)

In 1909, the Avalon Orchard Tracts Company was organized southwest of town through a Chicago firm's purchase of 720 acres of Ed Smith's ranch, which joined the Kuna townsite on the east, called the Avalon Nursery and Fruit Farm. Two years later, some of the land was platted and placed on record as the Avalon Addition. Many of the acres were planted in vineyards, apples, and prunes. Nampa Apple Orchard Company also incorporated in 1911. The shareholders acquired 240 acres southwest of town. The land was platted as the Kuna Orchard Tracts, and three commercial varieties of apples were planted. Other than "Avalon Orchards Tract" on property listings and Avalon Road, Avalon Orchards is gone. (Above, US Farm Security Administration/Office of War Information Collection, Library of Congress; below, ACDS, but originally from Kuna Library.)

With irrigation, farmers could justifiably be proud of their accomplishments. The picture above, from 1915, shows "Karnival Day" (then as now, people loved the "K" alliteration) on Main Street in downtown Kuna. Only the two-story structure, now the Arlene Building but then known as Sims Hardware, could serve as a fitting backdrop for the corn "high as an elephant's eye." The photograph below, which may have been from a fair, was used as a real-photo postcard. (Above, ACDS, but originally ISHS 81-87.11; below, Kuna Library.)

Hay was and remains a common agricultural crop grown in Kuna. This picture also shows an example of one of the several kinds of hay-stacking devices used before balers—in this particular case known as a "Mormon derrick." Victor Carlson, who arrived in Kuna in 1910, estimated that he had built more than 300 of them. Several are still visible around Kuna, even though they are no longer used, because they are picturesque and take up too little space to be worth the nuisance of removing them. (Above, ACDS; below, Kuna Library.)

The ubiquitous sagebrush could be cleared by hand or by using a team of horses pulling railroad ties. Common crops in the area included hay, clover, alfalfa, wheat, oats, barley, rye, potatoes, onions, beets, turnips, and cabbage. Farmers would work together to rent the use of machinery for operations such as threshing, as shown in the photograph below. By 1910, Ada County itself had 1,503 irrigated farms. In Kuna alone, irrigation brought the town's population from 75 in 1911 to 300 in 1912. But many Idaho farmers stayed with horse-drawn equipment until after World War II. (Both, ACDS.)

Kuna's agricultural heritage remained evident even in houses close to downtown. Note the chicken coop and outbuilding at this house at 204 West Fourth Street. Also reflecting the area's agricultural tradition, as well as the style of the time, houses themselves could end up resembling barns. Also note the concrete silo and the two older agricultural outbuildings located near it, as well as the other, older agricultural outbuilding located behind the house. The open window on the barn, used for putting hay inside it, is a characteristic of what is known as a "Mormon barn." (Both, ACDS.)

In 1916, the *Idaho Farmer* magazine predicted that the Gothic-arch barn would become the most prevalent construction type built on successful dairy barns. Now, there are only a few Gothic-arched barns still standing in Ada County. This particular style of barn is sometimes called a "Western" barn, meaning a central gabled section with lean-tos over the two side aisles. However, the upper level was designed to store loose hay and became obsolete once baled hay became more common. The classic barn gambrel roof, developed around 1900, provided greater headroom and storage room in the hayloft. Rural houses, and particularly rural barns and other agricultural buildings, were often never completely considered "finished," with the owners considering them a work-in-progress and building them, adding on to them, and tinkering and making other adjustments for a number of years. (ACDS.)

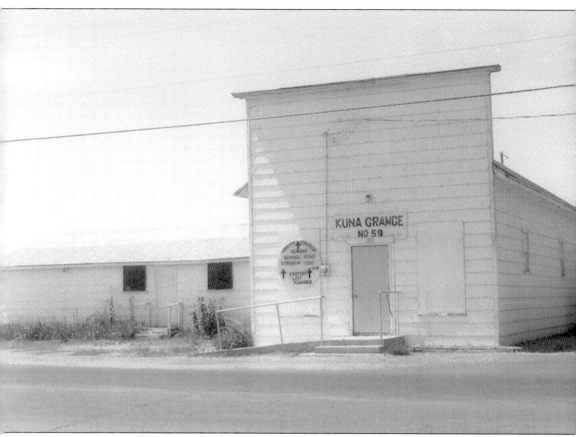

The Kuna Grange Hall at 189 Linder Road was the lumberyard from before 1916 and still displays the building's false front. During the fall of 1931, after many years of renting a meeting place like the old Odd Fellows Hall for $5 a month, the group decided to procure a building of its own. The Grange Hall was purchased in January 1932 from Ed Fiss. The contract of sale specified four equal yearly payments, but in April 1933, the final payment was made. The mortgage was burned by the oldest Granger, J.W. Beckdolt, a continuous member until at least the age of 91. In 1948, the Grange bought part of a Gowen Field barracks building, which it annexed to the hall. Grange women designed and built the kitchen themselves. The structure, which includes a stage, has also been used as a church and community meeting hall. The building was named by the Ada County Historic Preservation Council as a County Treasure in 2004. (ACDS.)

The Mora Grange, along with the Mora School, is one of the few buildings remaining from the town of Mora, located about four miles southeast of Kuna and settled from 1907 to 1909. The Mora Grange chapter was founded in December 1916, with assistance from the Kuna Grange. The Grange Hall itself is not currently used, and the Mora Grange subordinate chapter was merged with the Kuna Grange chapter. Reportedly, the building does not have running water or plumbing facilities. Marion Stroebel was master of the Mora Grange for many years. It is located on Eagle Road in the vicinity of Kuna and King Roads, just where the New York Canal makes a hard right at Eagle Road. At that point, the Boise Project diverts water from the NYC into a stream channel that joins Indian Creek. (ACDS.)

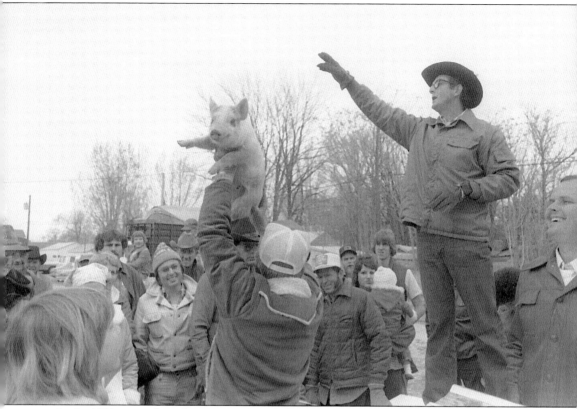

In the 1950s, a number of communities, including Kuna and the nearby town of Melba, in Canyon County, began conducting community auctions to raise money to help support polio victims. As they were held in agricultural communities, the auctions frequently featured agricultural products and livestock. As polio vaccination became more common and there was no longer a need to raise money for the community to help support its victims, the community auctions instead became focused on helping other groups. In Kuna, the community auction switched to helping victims of fire and became known as the "burnout fund" but continued, as shown in this picture from March 31, 1979, to keep its focus on agricultural products. Unfortunately, Kuna's Community Auction, which was typically held the first weekend in March in recent years, is on hiatus, though the Melba Community Auction is continuing. (*Idaho Statesman* morgue in BSULSC.)

Four

A Town is Born

In 1862, Congress passed the Homestead Act, which made land available to any family or person who was a US citizen or had filed a declaration to become one. Quarter sections (160 acres) of land were distributed free, provided the property was worked and lived on for five years. Such land could also be purchased after six months for $1.25 an acre. Numerous homestead claims were filed in Ada County, but its semiarid regions proved unsuitable for most homesteads.

In 1873, the Timber Culture Act passed, which was an attempt to increase humidity on semiarid lands by encouraging tree plantings. The act provided that any settler (who had previously been limited to a claim of 320 acres) might claim an additional 60 acres of public land if 40 acres were planted in trees. Later, the requirement was dropped to 10 acres.

In 1877, Congress passed the Desert Land Act, which allowed claimants a maximum of 640 acres of desert land at $1.25 an acre, provided they carry on some ditch construction before proof of land ownership.

D.R. Hubbard and F.H. Teed, anticipating the coming irrigation trend, planned a community on land they had homesteaded and filed a 200-acre claim on November 3, 1904, under the Desert Land Act. In 1907, Teed and Hubbard filed adjacent land claims, platting the area as orchard tracts. They marketed Kuna's access to the railroad as an enticement for people to homestead the land as follows:

> The townsite of Kuna stands on a beautiful plateau overlooking the main canal and the depot grounds. It lies midway between the Owyhee and the Sawtooth Mountains. The outlook on every hand charms all who see it. The soil and topography of the country is equal to any and superior to most in Boise Valley. There will be a great many thousand fruit trees planted this year and thousands of acres of land opened up for general farming.

But, Kuna remained sparsely settled until 1909, when irrigation water reached the area.

D.R. Hubbard was born in Iowa in 1858. He taught school before moving to Boise in 1902 with his wife and daughter. Hubbard saw that irrigation was necessary for successful crops in southern Idaho. While in Kuna, he built several dams, including the Kuna dam and the Hubbard dam, which held water runoff for irrigation during the summer. He also built the lower embankment of the Deer Flat Reservoir near Caldwell. Hubbard was active in promoting the construction of Arrowrock Dam on the Boise River, which, when it was built, was the highest dam in the world. When the dam was dedicated on October 4, 1915, he delivered the principal address. He was involved in both state and local Grange work, was a charter member of the Kuna Masonic Lodge, and a supporter of the Methodist Church. He was an Ada County representative in the state legislature in 1917, serving on agriculture and horticulture, forests and forestry, irrigation, reservoirs, and reclamation committees. Hubbard died on June 24, 1935. (ISHS.)

Fremont Teed was Hubbard's brother-in-law. Teed's wife, Lucy, told the following story of how they happened to settle: The Teeds and Hubbards drove to Indian Creek to picnic. Hubbard remarked about the quality of the soil and jokingly asked Teed why he did not take a claim and start on the townsite. Teed said he might consider it if the territory was still open. He went to Boise the next day and found it was the last day on which he might enter a desert claim. He filed under the Desert Land Act for sections consisting of 200 acres. (Patent No. 2019, November 4, 1903) On December 14, 1904, he received Desert Land Patent 2019, Final Certificate No. 533, for the above described property and paid $250 for it. He came to Kuna on May 15, 1905, and settled on a desert claim in Section 23. In Land Section 1W, he owned a lumberyard and post office. He also contributed the land for the Methodist Episcopal Parsonage. (Aldis Garsvo, but originally from the Kuna Library.)

In an effort to promote the area, Hubbard placed advertisements in the local Boise newspaper, the *Idaho Daily Statesman*, that claimed, "To Build a City of Kuna . . . We want 200 partners to help build a city." This ad ran in the March 9, 1909, issue. For sale at $100 a lot, 200 lots were available. The Kuna townsite was sold at public auction on May 4, 1909. A special train consisting of four coaches from Boise, Nampa, and surrounding areas brought people out. Before the drawing, 144 lots were sold, and the remainder were auctioned. The best lots in town sold for $25,000. Other lots sold for prices ranging from $10,000 to $2,500, for $25 down in cash and $5 a month. The average price of the best lots in the four neighboring towns was $10,750. (ISHS 74-91.47.)

In 1882, the Oregon Short Line Railroad set up a construction camp by Indian Creek where the Boise–Silver City Road crossed, naming it Kuna. This became the first site of settlement in Kuna. This early camp moved along with the railroad since there was no reason for a town there. Until the railroad station shut down in 1887, town residents earned money hauling goods to Boise. The early town consisted of at least three warehouses, a depot, and a post office. The only remains of the old town are some excavations, the remains of a corral, and a little graveyard on the hill across the railroad track. While people sometimes referred to it as an Indian graveyard, names and ages were legible at one time; they were the names of white people, mostly children. Older residents reported that they were the 11 children taken in the diphtheria epidemic; they would have been children of railroad workers. (ISHS 2063-51.38.)

Settlers who claimed land through the Homestead Act or Desert Land Claim needed to live on the selected property for five years and meet specific regulations to get the land. Many people would build "prove-up" shacks, which they would live in as they made improvements on their property to get final patent on the land. Some of these prove-up shacks still exist in Kuna and the vicinity. Later, as the settlers became more prosperous, they could build more substantial houses capable of supporting a family, as shown in the above photograph. (Above, ACDS; below, ACDS, but originally from Kuna Library, 81-50 P13C.)

Other buildings could be dated to as far back as the time of Kuna's settlement. However, such buildings were frequently either modified to serve a separate purpose as the needs of the farm changed or simply torn down, with their wood used to build another, more appropriate structure for the farm's requirements of the time. (ACDS.)

This smokehouse on Orchard Street is notable for being one of the few structures in the area constructed entirely of basalt, a rock produced from volcanic activity. In surrounding communities, such as Melba's Halverson Bar, homesteading shacks were constructed of it, because little or no wood was available. (ACDS.)

Details on who exactly discovered the 1,000-foot lava tube that later became known as the Kuna Cave are sketchy and contradictory. In one account, it was located by two cowboys in 1879 who entered it using a rope. In another, the Kuna Cave was discovered in 1890 by Claude Gibson, a Boise lawyer, who descended into it with a group of friends. (Kuna Library.)

This picture was taken by Robert Limbert around 1910 and appears in *Unknown Places in Idaho*, an illustrated 54-page brochure published by the Union Pacific Railroad in 1927, touting the scenic wonders and wildlife of the state of Idaho, all of which, of course, could be reached via the Union Pacific Railroad. (Boise State University Library, Robert Limbert Collection [photograph 1890].)

The Kuna Cave became a landmark and frequent photographic subject. It has always been a popular spot for picnics, school groups, and friends. Arrowheads and other Native American artifacts have been found in it. One area of the cave is so small that it is known as "Fat Man's Misery" because it is difficult for larger people to make their way through, and it is recommended that even smaller people will need kneepads. The cave is so vandalized that the Bureau of Land Management, which controls the area, does not publicize its existence or location, beyond the fact that there is a Kuna Cave Road. The photograph above shows Kuna founders the Teed family at Kuna Cave. The image below is from a picture postcard. (Both, Kuna Library.)

Rumor has it that the Kuna Cave was actually part of an extensive underground cave system that reached as far as the Snake River but that the Army Core of Engineers collapsed it for safety reasons. Also for safety reasons, first responders in the area undergo periodic training sessions, like this one from May 14, 1983, to help familiarize them with the cave in case someone gets lost or injured there. People reach it using a 35-foot steel ladder that drops them into its dark chamber. It is also rumored to contain $40,000 in gold, stolen by a robber who took it from a stagecoach on its way from Silver City but found the burden too heavy to carry while being pursued. (Both, *Idaho Statesman* morgue in BSULSC.)

Five

HOUSING KUNA

Jennifer Eastman Attebery notes the following in the book *Building Idaho: An Architectural History:*

> Rural architecture is primarily vernacular; that is, it is designed and constructed by owners and builders without the involvement of trained architects. In the countryside, architects were employed primarily for institutional buildings—rural schools and churches—and only very occasionally for a farmhouse or barn. Second, although rural architecture does follow certain basic patterns throughout the state, it is also highly regionalized; and that regionalization is more obviously keyed to local materials and environment than are the regions of urban architecture.

Another definition of vernacular architecture is that it has few architectural details that are specific to a particular period or style. While some structures may have had professional builders, owners in rural areas constructed their own buildings into the 1920s and later, which covers much of the period when many Kuna houses were built.

A number of houses in the Kuna area retain at least some degree of original architectural integrity. While there are not enough of them to warrant setting up a historic district designation in the National Register of Historic Places, some of the individual homes and neighborhoods could be eligible.

In addition, several houses in the Kuna area, especially in the residential neighborhoods surrounding downtown, have been recognized by the Ada County Historic Preservation Council as "County Treasures." Such buildings are honored at an annual ceremony with a brochure and have a sign posted out front for a period of time noting their designation.

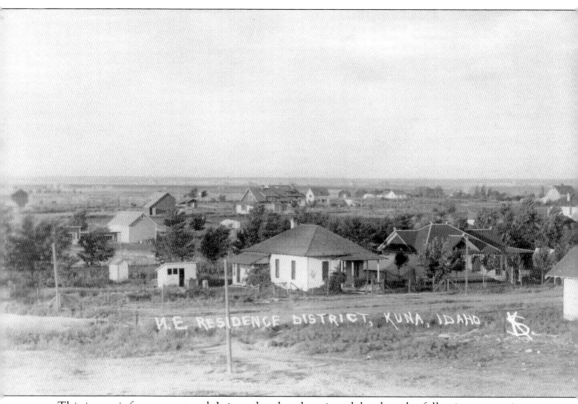

M. E. RESIDENCE DISTRICT, KUNA, IDAHO

This image is from a postcard. It is undated and unsigned, but has the following text written on the back: "The house I marked with a cross is Mr. [presumably Frank] Fiss's house. The corner of the house shown is a very pretty brick veneer house. The Methodist Church they are just starting is just across the street from Fiss and a little south." Since the Methodist church was put up in 1916, this provides some means of dating the image, likely around the time of 1915 or 1916, and placing it geographically, most likely along Fourth Street not far from Franklin Avenue, which is where the Methodist church is located. Note the chicken house on the property in the center of the image, as well as the numerous barns and other agricultural buildings visible in the distance. Some of the houses are even more than one story tall.

With the town of Kuna greatly expanding in size during the 1910s, many of the houses were built in various manifestations of the then current Craftsman style, popular during the period between 1905 and 1930, which was when many of the houses in Kuna's "old town" residential section were built. The primary emphasis was on functionality with only the simplest of ornamentation. This simplicity in design was considered to be a reaction to the ornate Victorian style that preceded it. On the interior, such houses were often designed to be of the Bungalow style, meaning the house featured a large living room and dining room as well as a hall, bedroom, and bathroom wing, often with an open front porch. (ACDS, but originally from Kuna Library.)

Some of the oldest houses in Kuna were typically built in a simple style known as a pyramidal roof cube or a wide-hipped cube. The house itself is square with a chimney in the center and a roof that comes up evenly from all four edges, with no gables or eaves. The interior design would be one known as a foursquare, a four-room arrangement under a pyramidal roof. Such a house might be the first one built on a homesteaded property, with a later, more elaborate house built after the farmer had achieved some level of prosperity. At that point, the family might build a house—or, if they were really prosperous, have one built by a professional builder—with more stylish features of the period, such as a Queen Anne or a Craftsman home. (ACDS.)

With Kuna's hot and dry climate and in the age before air-conditioning, many of the town's older homes featured large porches so the residents could attempt to gain relief during the worst part of the summer. In this particular structure, notice also the elaborately scalloped shingles, which are typical in a particular style of Queen Anne house known as the New England Shingle, as are the simple but classically inspired columns on the porch. Shingle houses were also more likely to be symmetrical, as shown here, compared with some of the more asymmetrical, as well as larger and more elaborate, Queen Anne houses located in more urban areas such as Boise. The two protuberances to the right of the upper window bring electricity to the house. (ACDS, but originally from Kuna Library.)

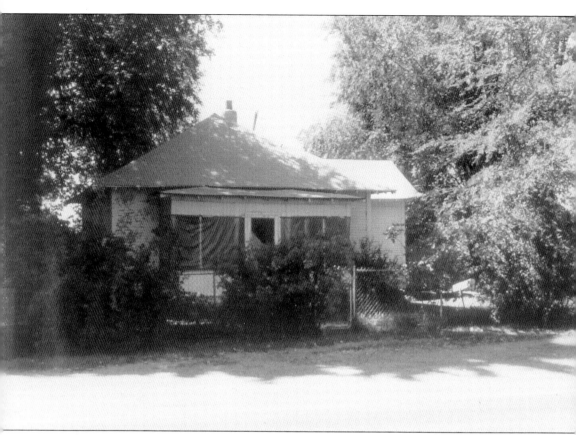

As described in the *Ada County Historic Site Inventory*, "many houses exhibit classical architectural details mixed with traditional or vernacular plans. As is the case with farm buildings, many of the farmhouses surveyed during this project were altered over time." The building shown in this photograph is a good example. It is another specimen of the pyramidal-roof cube house common in older Kuna and in western Ada County, in general, but with modifications that makes the house style less obvious. The photograph shows what appear to be an additional room and porch, which may have been itself enclosed as a later modification. There are several examples of this more modest type of house, known as a hipped-roof cube, which was popular from 1900 to 1940, on West Fourth Street. (ACDS.)

This pair of photographs shows how many older homes in Kuna remain largely unchanged from their construction. This house at 425 West Fourth Street at the corner of Avenue C was built of white brick, a popular construction material in Kuna at the time, especially in buildings constructed, as this one was, by the Negley Brothers Company. Note that the home is essentially unchanged in the later photograph except for the porch being enclosed in glass. This house was recognized by the Ada County Historic Preservation Council in 2009 as a County Treasure. According to the council, it was identified as being built in 1911 and called the Atkins house. Also, notice how much higher the building and yard originally were from the street level. (Both, ACDS.)

Residential buildings could include features from a variety of house styles, not just because residents, designers, and builders picked up features that they liked from pictures they saw, but because structures—particularly in a rural area more concerned about function than style—were often modified and, in the process, acquired additional features popular in the era. This house has some Craftsman features, such as the open porch, which had not yet been enclosed, and the exposed rafters visible under the roof and particularly on the porch. The home's columns on the front porch could be considered to be classically influenced. The porch appears to have its original siding, while the house itself has more modern siding; consequently, the upper story may have had ornamental siding like that used on some Queen Anne buildings. (ACDS.)

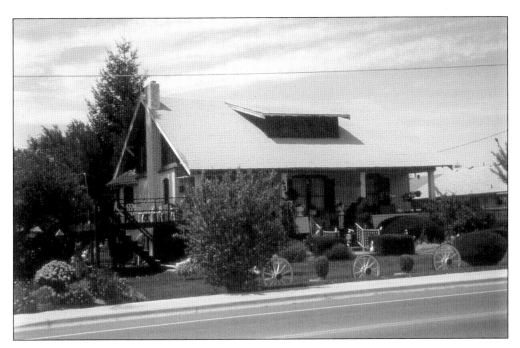

This house at 629 North School Avenue (above) was also originally constructed of white brick. While it has Craftsman features, it is actually considered vernacular. The home, which still stands today, was recognized by the Ada County Historic Preservation Council as a County Treasure in 2009. The council identified it as the Kindred house, said it was built in 1915, and reported that Vertice Hostetler taught a first-grade class of 44 students in the living room in 1920 when it was also known as the Fiesher house. Farmhouses, like this one (below) at 300 North Eagle Road east of Kuna, were also often built in the Craftsman style. (Both, ACDS.)

This house (above), located at 423 Locust Avenue on the corner of Fourth Street, is built of wood using Craftsman features. It has since been fenced off, which makes it more difficult for the casual passerby to see its features. The Ada County Historic Preservation Council recognized it in 2009 as a County Treasure. According to the council, it was identified as the Keller house and was built in 1915 by the owner of the Kuna newspaper. His widow continued to live in the house until the 1960s. This Craftsman bungalow (below), at 701 Franklin Avenue, still stands today. (Both, ACDS.)

This Craftsman house (note the large overhang on the side eaves), located at 581 Franklin Avenue, not only still stands today but is also painted a cheerful bright yellow. Note the carriage house in the back, which also includes Craftsman features, that was used for a garage; it still stands as well. (ACDS.)

This Craftsman house at 423 North Marteeson Avenue at the corner of Fourth Street was built in 1913. It not only stands today but also, as of 1998, is being lovingly restored by the current owners. It was recognized by the Ada County Historic Preservation Council as a County Treasure in 2009. (ACDS.)

The house in the above photograph, located at the corner of Elm Avenue and Fourth Street at 402 West Fourth Street, shows other common Craftsman features, such as exposed roof rafters and decorative beams or braces showing under the gables. This house was torn down in the 2000s, but a new home was built on the same foundation and in a similar Craftsman-inspired style. Pictured below, the house at 182 West Fourth Street still stands today, though the siding was replaced so that it no longer shows the distinctive Craftsman shingles visible on the front in this picture. (Both, ACDS.)

In comparison with the Queen Anne style that was popular earlier, Craftsman houses featured a low-pitched roof with gables and wide, unenclosed eaves. Even simple homes of this era included Craftsman features, such as the porch with pillars and overhanging eaves shown in the above photograph. These houses at 204 West Fourth Street (above) and 759 Franklin Avenue (below) still stand today. The residence shown in the photograph below may have had its porch enclosed at some point, in contrast to the house in the above photograph that still shows an open porch. (Both, ACDS.)

These houses at 325 Cleveland Avenue (above) and 722 West Fourth Street (below) are of the Queen Anne style. Identifying features include a steeply pitched roof, usually with a dominant front-facing gable, patterned shingles, and cutaway bay windows, particularly visible in the detail above. Because it was popular from 1880 to 1910, a number of the older homes in Kuna are built in this style. Both of these houses still stand today. Part of the popularity of the Queen Anne style was due to the fact that published house plans were distributed through the popular press. (Both, ACDS.)

Even though this house was just a block from downtown Kuna, it originally featured agriculturally based outbuildings such as a chicken house and a shed. It was built in 1920, the height of the Craftsman era. Notice how the shed, like the home, also displays Craftsman features such as the "X" trim on the door. The residence, located at 527 Marteeson Avenue, still stands, but sadly, the outbuildings have been torn down. The house itself has received extensive additions in 2003, though it appears some effort was made to keep Craftsman-style features in the addition. Incidentally, "Marteeson" is said to be a portmanteau word of the names of several of the town founders, including Teed. (Both, ACDS.)

In another indication of Kuna's agricultural roots, the house above resembles a barn, with its gambrel roof. The way the roof notches into the house also shows some Colonial Revival influence, which also includes decorative pediments over an accentuated front door and multipaned sash windows. This particular subtype of Colonial Revival is known as a Dutch Colonial Revival because of its roof shape and is the only Colonial Revival house documented in Kuna. This house below, built in 1920 on 2067 East Kuna Road, stood on property once part of Avalon Orchard. The house itself still exists today. (Both, ACDS.)

Several houses in this area also include features typically considered to be of the Tudor Revival style. It was popular nationwide from about 1890 to 1940. Tudor Revival houses are identified by a steeply, pitched roof usually side gabled. It often has one or more prominent cross gables. They can be made of brick or, as seen here and in several other examples on the same street, in stucco. One of the two large pine trees shown in front of the house at 267 West Fourth Street blew down a few years ago, making its Tudor-style features much easier to see. (Both, ACDS.)

Another common building material is Miracle Brick, man-made masonry intended to resemble stone. The house above at 402 Linder Avenue still stands. Below, the J.H. Ross family homesteaded on 40 acres on Linder Road in 1906. Ross helped get Kuna's first school started, and in April 1978, School Street School was renamed after him. His son Arthur was born on June 15, 1894, came back to Kuna after retiring in 1960, and moved into the family farmhouse on 1223 North Linder Road. Though it was thought to be one of Kuna's oldest buildings and considered for a museum, it was torn down in the early 2000s due to compliance concerns. Today, the site is a townhouse complex, but one street in is named West Art Court, after Arthur Ross. (Both, ACDS.)

This house, located at 361 West Fourth Street, is of a much simpler architectural style with considerably less ornamentation than the earlier Craftsman style. It may represent a transition to the Tudor Revival style of architecture that was coming into vogue about that time, especially because there are several other Tudor Revival houses in the area. In 2009, the Ada County Historic Preservation Council named it as a County Treasure, identified it as the Sumner-Wilson house, and said it was built in 1930. The residence shown below is another example of the Tudor Revival style. This building at 281 West Fourth Street at the corner of Avenue B still stands today. (Above, Sharon Fisher; below, ACDS.)

Many houses in Kuna reflect more than one style. This structure, located at North 600 Franklin Avenue, which was built in 1950 (more recently than the others), appears to exhibit both Tudor Revival and Spanish Revival influences. It has a Tudor-style roof and some Spanish Revival features such as the clay tile vigas in the eaves. Spanish Revival style was most typical in the 1930s and includes characteristics such as red-tile roof coverings, low-pitched roofs, stucco wall cladding, and arches above the doorways and windows. The Tudor Revival style, also popular in the 1930s, includes a steeply pitched roof, a dominant front or cross gable (this building has two), tall and narrow windows, and large chimneys. Tudor Revival architecture often also features decorative half-timbering, but the Tudor Revival houses in this area of Kuna do not have them. (ACDS.)

Six

THE MIND AND THE SOUL

After decades of neighborhood schools, statewide school consolidation brought 15 school districts together as Kuna Joint School District No. 3 in 1950. Five elementary schools were used throughout the district, with all students coming to Kuna High School for their secondary years. The elementary schools were Kuna Grade School, Columbia, Happy Valley, Highline, and Mora. The other schools consolidated into the Kuna School District are Fairbanks, the oldest school in the district; Hornbeck School, also called Coleman School, established in 1904 or 1905; Mountain View School, established in 1906 and merged with Kuna in the 1920s; Lynden Park, established about 1913 and closed in 1948; and Poplar Grove School, established in 1919. Its new Nagel School building burned to the ground in December 1923 due to a fire of unknown origin. Nothing was saved, but the building carried $4,000 insurance. It closed in 1939, and the property was sold to the Highline Grange in 1947.

Junior high students continued to attend school at the high school until 1964, when they moved to their new school on School Street. In 1974, it became Ross Elementary School when the junior high moved to the old high school building on Fourth Avenue. As late as the mid-1950s, schools in Kuna closed in the fall for a harvest vacation.

In 1957, there were a number of new developments in the school district. The district took over the lunch program from the PTA, which had started it in January 1946. Enrollment in the Kuna School District was 710, with 38 graduates. By 1966, enrollment in the high school alone was up to 272.

In 1972, the school district spent $55,000 and purchased 40 acres for a new high school from Grace Mathews. In 1974, students moved into the new high school on Boise Street. The construction was financed with bond funds totaling $1,008,000, approved by voters in 1973. The school was built to accommodate 600 students. It is now the middle school. Mathews lived in her home until 2001. After her death, the school district remodeled the residence into a district administration building.

Kuna Junior High, next door to Hubbard, was built in 1981 at a cost of $2,500,000. Starting in the fall of 2002, the school became the Fremont H. Teed Elementary School, housing students in grades four and five.

Also in the fall of 2002, a new high school opened on Deer Flat Road. The $12,500,000 school was built to accommodate over 1,100 students. The school district in 2002 had an enrollment of over 3,200 students and a graduating class of 185.

By the fall of 1908, Kuna had enough children to open a school. The community pulled its students from the Highline School District and elected trustees J.H. Ross, A.P. Jacobs, and W.H. Williamson. School opened in a 16-foot-by-24-foot tent loaned by the Hubbard-Carlson Construction Company, with 14 pupils and Gaylord Greene as the first teacher. Because of the weather, the school moved into the Teed house and post office, rent-free, after the Teeds moved to their new home on the north edge of town. The Teed homestead sat to the east of the city park where the Grange Hall now stands. As with Kuna, Mora (pictured below) also opened its first school in a tent, in 1909. (Above, ACDS, but originally from Kuna Library; below, ACDS.)

The population of Kuna at this point, around 1911, was approximately 75. The photograph is captioned "kids in front of house" but is identified in the book *The Settlement of the Kuna Region* as being the Owyhee School, west of Mora. The school was shut down in 1914 after it was determined that irrigation would not reach it. (ACDS, but originally from Kuna Library.)

This photograph is identified as Kuna Butte School, originally known as Poplar Grove. Kuna Butte, also known as the Kuna shield volcano, is thought to have been the source of much of the volcanic activity and lava rock found in the region. While there was a settlement at Kuna Butte, families typically came to the Kuna area for trading purposes. (Doug Rutan.)

The school district purchased seven acres of irregularly shaped land, known as Rattlesnake Hill. In 1910, the first school building, known as the White Brick School, was built for $7,000, along Indian Creek, the site of the present Indian Creek School. It was a four-room school, and only two rooms were ready for the beginning of school that year. The first graduate, in 1914, was Arlene Hale, after whom the Arlene Building was named. The district was proud of its fleet of school buses. In 1916, a $9,000 addition was completed, containing six rooms with steam heat and plumbing. Sadly, on January 8, 1925, fire destroyed the White Brick School building, as seen below. The structure was valued at $25,000 but was insured for only $14,000. (Above, Kuna School District; below, Kuna Library.)

This photograph is identified as "Kuna School 1908." What is particularly interesting is that the names of all the students, some of whom have last names that crop up later in Kuna history, are written on the back (right)—like Fiss, the family that built the Kuna Mercantile and millinery shop; Ross, a family that was instrumental in forming the Kuna School District; Neglay, a family of professional builders; and Bodine, a family that became known for agriculture. Due to the date of the picture, this is likely to be the school located in the former Teed homestead building. (Both, Kuna Library.)

Kuna - Idaho School 1908
Rosa Rasbo - Teacher
Margaret Ross Carlson
Harald Fee
Gordon Ross
Norman Neglay
Marion Neglay
Helen Williamson
Norman Ross
Roy Hodkinson
Back Row
Clara Bodine
Lena Neglay
Hazel Bodine
Lilian Ross
Anabelle Ross
Winifred Ross
Clifford Hodkinson

6530

In 1924, a new high school was opened on Fourth Street. It cost $40,000. In 1937, an addition was made that included an auditorium and classrooms. A new gymnasium was built in 1947 that provided a basketball floor of regulation size with bleachers seating 1,000. The gym was also the site of many concerts and plays; consequently, in 1960, the stage in the high school gym was enclosed for dressing rooms. A shower room was built to connect the agricultural room to the gymnasium. The high school on Fourth Street served Kuna for 50 years. The building was vacant for 15 years before being razed in 1996. Today, only the gymnasium, which is used for community activities and school offices, remains. The window over the front entry of the 1924 school is now a part of the new Kuna High School, which opened in 2002. (Kuna School District.)

Bowmont School (above) was organized on January 19, 1912, within the city limits of Bowmont, a nearby community in Canyon County. It was closed and merged with the Kuna School District in 1954. Columbia School (below) was established in 1905. This structure was built in 1919 by W.H. Beckdolt and considered to be one of the finest rural school buildings in the area. The school stood at the southeast corner of Meridian and Columbia Roads. The Kuna School District was still using this building when it was destroyed by fire in 1958. About 37 students attended the school. (Both, Kuna School District.)

Kuna School staffers identify the photograph above as two different schools, probably because both schools were made of the same basic wide-hipped cube construction. Fairbanks School, opened before 1904, was considered to be the oldest school in the district, while Ten Mile School was established in 1912 and is now incorporated as part of the current Ten Mile Community Church. Ten Mile School was part of the Ten Mile community, which included the Ten Mile Grange, located at Columbia and Eagle Roads, a store across the road from the Grange, and the school less than a mile east. The picture below shows students at Columbia-Rye Patch School. (Both, Kuna School District.)

The Orchard Ridge School (above) was established in 1919 and merged into other schools—part with Kuna and part with Meridian—in 1952 or 1953. Highline School, also known as High Line School, was established in 1899. It was located a half mile east of the county line and three quarters of a mile south of Amity Road. The original building was a dance hall and was replaced by a new structure in 1920. The school was later remodeled into a private residence. Highline, Kuna, and Happy Valley were the three operating elementary schools left after Columbia burned in 1958. (Both, Kuna School District.)

Happy Valley School was established in 1906 and located a half mile north of the Latter-day Saints church on Robinson Road. It was originally a one-room school building. In 1910, the school was moved to the northwest corner of Kuna Road and Happy Valley Road. In 1916, a redbrick, one-story building was constructed to house both elementary and secondary students and replace the old wooden school. By 1920, the student population of Happy Valley School had grown so large that the school trustees solved the problem by raising the roof and putting second-story walls beneath it. In the spring of 1964, the school was torn down. The lava rock retaining wall and front sidewalk are still visible at the corner today. (Both, Kuna School District.)

The Beckdolts were the only family living south of the Ridenbaugh Canal. Not long afterwards, the George Wood family arrived from Iowa and settled the adjoining 160 acres. Because they both had children, a one-room school was built on the property line and began operating in 1905. It was located a half mile south of the Columbia School along Mason Creek on Kuna Road. (Kuna School District.)

After White Brick School burned, "Red Brick School" was built on the same site for $17,000 in 1926, with a wing added in 1950. However, it too burned on May 15, 1954, three days before the end of the school year. The 12-room school, insured for $45,000, was a total loss. Classes were held in the high school until Indian Creek was built in 1957. (Kuna School District.)

Sports have always been popular in Kuna schools. This is the football team from Happy Valley High School. Writing on the back of the photograph notes the 1930–1931 team in offensive formation. Names include La Norm Hastruter, Ross Blattner, Percy Lowe, Merle Brody, Fred Barrett, Milton Blattner, Forrest Gould, Lou Guentz, Emil Lowe, Ed Allen, and Melvin Johnson. "Athletics must be part of every school curriculum," notes a 1924 *Kuna Herald*. "This varies, however, from clean, manly, sportsmanlike exercises on the field to the hickory stick workouts of 40 years ago. There are, indeed, remedies for some present day problems." Football remained popular with a new football field being built behind the junior high, with lights, in 1957. (Both, Kuna Library.)

Baseball was also a popular sport. This team is wearing uniforms indicating that they are from Kuna High School. In 1954, the school colors were changed from orange and black to gold and black. In September 1964, the new Kuna Junior High School, currently Ross Elementary School, opened and featured baseball fields. An open house was held in the new school on Saturday, August 15. Since the school was located out of town, a school bus was used to transport community patrons to the open house every half hour. A pageant was held, with Arthur Ross as the master of ceremonies. Alumni and other students who attended Kuna schools before 1920 were honored. Baseball games were played on the grounds. (Both, Kuna Library.)

The picture above shows a 1938 aerial view of the 1924 high school. Originally, some students walked, a few rode bicycles, and some went by horseback or in buggies. A barn was built to house the horses that had to stay all day. Beginning in 1910, the school district transported students, first by horse and wagon. The district purchased its own fleet of engine-powered buses by 1915. The district also contracted with local farmers to transport students. Some farmers owned school buses, but some converted trucks to transport vehicles in the winter. The district operated 14 school buses in 1965 and 35 by 2002. The picture below shows the district's 1937 school bus, still used today for ceremonial occasions, like parades. (Above, ACDS; below, Kuna Library.)

The Mora School, a two-story brick building constructed in 1910 for $2,900. Like Kuna, Mora was located on the Silver City Trail, about four miles southeast, and was settled between 1907 and 1909. While the Mora community was not as large as that of Kuna, enough families had children to support a school. The school's wellhouse and gate pillars were constructed of the basalt rock common in the area, also known as lava rock. The school, located on Kuna Mora Road, closed in the mid-1950s due to a contaminated well, and the district was consolidated in the Kuna Joint School District No. 3. The district considered reopening the school until it found out it would cost over $20,000 to fix the problem. The building was sold in 1966 for $2,200 and is one of the few Mora structures still standing today. (Kuna School District.)

An architectural elevation drawing (above) from the early 1960s shows the Ross Elementary School. The photograph of the school under construction (below) was taken on February 6, 1978. The school was named Ross after the Arthur Ross family, who settled in the area and were strong supporters of the school district. (Above, Boise State Library Special Collections; below, *Idaho Statesman* morgue in BSULSC.)

Churches started forming in Kuna at almost the same time as schools did. In fact, it was not unusual for church services to be held in schools. In November 1908, a total of 11 people met one Sunday in the school tent to organize a Sunday school. Because there were three Methodists, as well as one Episcopalian, one Baptist, and one Congregationalist, the tiny congregation voted to call it the Methodist Episcopal Sunday school. The picture below is marked as "S.S. Easter S. 1910, Kuna." Note how similar the building is to the picture of the school on page 91. And look at all the elaborate Easter bonnets! Easter in 1910 was on March 27. Temperatures in March 1910 were exceptionally warm, with the average high reaching 41 degrees, compared to 35 and 36 the years before and after. (Both, Kuna Library.)

S.S. Easter S. 1910. Kuna

Fiss Hall, located upstairs above the Kuna Mercantile, served as a meeting place for the Kuna Methodists until they put up their own building in 1916. The Reverend Arthur Hays arrived in Kuna from Indiana on October 18, 1910, and served as the first pastor of the Kuna Methodist Church until 1912. Hays was also a member of the first board of directors of the Kuna cemetery and helped clear sagebrush from the site. By October, the Methodist Episcopal Church had partially completed the building on Franklin Avenue and West Fourth Street. In mid-October, the church held an all-day meeting and raised $1,500 to finish the construction. Shown above, this picture was taken soon after it was first dedicated. The building is still used as a Methodist church. (Above, Kuna Library; below, ACDS.)

Seven

DOWNTOWN, THE HEART OF KUNA

In 1909, Kuna's downtown only included a bank and a hotel, but it grew swiftly. An up-to-date creamery and artificial ice plant, operated by electricity, were built in 1914. By the end of 1916, Kuna was an incorporated town with a population of 250. It had sanded streets, electric lights and power, and a city water system provided by a deep well.

By 1919, Main Street included the Kuna Herald Building, the Kuna State Bank Building, the Kuna Lumber and Coal company, a structure called George's Place that hosted the Kuna Barbershop and the Kuna Confectionery, the Kuna Post Office, the Kuna Mercantile company, the Kuna Livery Feed & Stable, and the Kuna Hardware Company. Other businesses included two blacksmith shops, a garage, restaurant, print shop, two lumberyards, an artificial ice plant, barbershop, pool hall, produce store, theater, drugstore, planing mill, carpenter shop, milling and elevator company, butcher shop, a creamery, a millinery shop, a bakery, and a meat market—but no bars. This was in addition to an accredited school and two churches. Other additions to Kuna in the early years included two service stations.

The area behind the Grange building used to be a park with a sprinkler system, but in 1955, a carnival came to town and the Grange allowed it to set up there, and all the driving over the park broke the sprinkler system. In 1986, the Grange considered selling its property for a car wash.

In 1968, the village of Kuna was incorporated as a city. The current president of the council, Lawrence Hays, served as acting mayor. In the fall, the first mayoral election was held. Hays ran against Mary Pride, with Mary winning the election. During her term as mayor, the 41 lots of land behind the old city hall were acquired from Ada County. The land was deeded over to the city with the hopes of it becoming a future shopping center.

Kuna's downtown still shows its history.

The Arlene Building, named after Kuna's first high school graduate, is the only structure in Kuna in the National Register of Historic Places. Built in 1910, it has hardwood floors from the old Kuna High School gymnasium and the original, elaborately designed punched-metal ceiling. Formally known as the Lilyquist-Christenson Building, the two-story brick structure was erected in 1910 by Charles Lilyquist, who died in an accident while building it. The structure perhaps became best known as the Sims Hardware Building (above), and some of the details of those early days remain today, including the metal ceiling, a supporting column, and a metal track for a sliding ladder used to reach items on high shelves. (Both, ACDS.)

Kuna's downtown began to take shape early in 1908 when Frank B. Fiss erected a two-story frame building and put in the first stock of general merchandise. In the spring of 1910, the town's first brick building, a double store with an assembly hall, office, and living quarters above, was completed by J.H. Neglay and Sons and Ed Fiss. The Kuna Mercantile was then organized, with F.H. Teed as president, F.B. Fiss as manager, and Ed Fiss as secretary-treasurer. Sophia and Helen Fiss, sisters of F.B. and Ed, opened the first millinery store in the building. Because it featured a community hall on its upper level, it was also known as Fiss Hall. The undated picture below shows the mercantile inside, with Frank Fiss. (Above, ACDS, but originally from Kuna Library, 81-17 P8C; below, Kuna Library.)

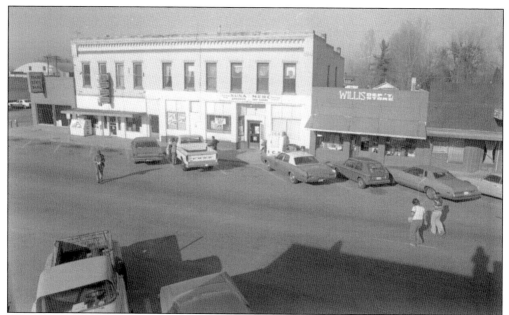

In the late 1910s, Clarence Biggs purchased the store from the Fisses; and in 1922, the Tallmans purchased it, naming it the Tallman Merc. The Tallmans were not newcomers to Kuna. At one time, Elva Tallman had managed the Kuna Hotel, where she served as many as 300 meals daily. George Tallman had a barbershop and candy store in the building on the south side of First Street called George's Place. In 1929, the Tallmans sold the Tallman Merc to O.F. Clapper, then repurchased the store in 1932. The Tallmans also bought the J.W. Booher Mercantile, found to the east of the Kuna Merc. It was still known as the Merc in December 1976 when these pictures were taken. (Both, *Idaho Statesman* morgue in BSULSC.)

In 1939, the Tallmans sold the business to their son Hap, who kept the store until 1942, when he joined the Navy. Hap Tallman sold the Kuna Merc in 1942 to the Golden Rule chain. Until 1945, there was a public pay telephone in the stairway of the building because farmers still came to town to make their telephone calls. In the 1950s, a sundries department was added to the store. By the 1970s, the store carried groceries, fresh meat (also offering custom meat-cutting), dry goods, cards, and gifts. The above picture was taken in July 1978, not long before the Kuna Mercantile closed in October 1980. The Kuna Mercantile building still stands today. (Above, *Idaho Statesman* morgue in BSULSC; below, ACDS.)

In 1909, the Kuna Savings Bank was organized with $15,000 and located in a room off the Kuna Mercantile until February, when L.A. Martin of West Bend, Iowa, erected this two-story frame building. He also put in a lumberyard and named it Kuna Lumber and Grain Company. He lived in an apartment above the store. The bank was liquidated in 1915. The picture below, which was also used as a postcard, is of the Kuna State Bank. While the Kuna State Bank building was "modernized" at some point before the mid-1960s, a windstorm tore down the applied paneling in the early 2000s. The building, still home to a financial services company, was restored and looks today much as it did originally. (Above, Kuna Library; below, ACDS, but originally from Kuna Library.)

Joseph Neglay came to Kuna from Everett, Pennsylvania, on March 14, 1908. He filed a claim on relinquished land, cleared sagebrush in 1909–1910, and planted an apple orchard. Neglay took in boarders in April 1909 in a tent east of the *Kuna Herald* office. In 1909, he built the first hotel in town, which was then sold to H.A. Thomas. Neglay did plastering, brick laying, and concrete work in Kuna. On February 9, 1908, Frankie W. Davidson came to Kuna from Wisconsin and settled on homestead land. He cleared sagebrush and planted his first crop later that year. He entered business as a building contractor in a shop in the Boise-Payette lumberyard and finished his first store in Kuna in 1909, as well as building a hotel. This is likely the hotel built by Neglay. (Both, Kuna Library.)

The need for rural free delivery was an important problem sponsored by the national Grange organization. Until it was introduced in Indiana in 1880, residents of rural areas had to either travel to a distant post office to pick up their mail or else pay for delivery by a private carrier. In Kuna, Mail Route No. 1 was established in 1910 with E.G. May as the carrier. By 1915, enough families had moved to the area that a second rural route was organized on June 17. The rural service was triweekly until daily service was begun on November 16, 1915. (Both, Kuna Library.)

On August 19, 1905, a post office was established in the Teed home, with F.H. Teed commissioned as the first postmaster. The first mail pouch was received on August 28, 1905, via the Oregon Short Line Railroad. Post office receipts the first year were $3.16. But in 1909, when the Teeds gave their home to the school, the office was moved to Teed's office, then later to its own new building across Main Street. In the picture above, the use of Miracle Brick, a masonry product intended to resemble cut stone, is visible on the post office's exterior. While the Miracle Brick post office unfortunately no longer exists, the material was used on several other buildings, including some that still survive, such as this one at the corner of Main Street and Avenue C, shown below. (Above, Kuna Library; below, ACDS.)

This undated picture appears to have been taken from the water tower, located in the city park, based on the image of the rail in the lower right-hand corner. The water tower still stands today, though it does not display the name of the city of Kuna on it, as do the water towers in some

neighboring communities. The picture is entitled "Panorama of homes and south side of railroad track and creek." Today, Kuna's water tower is also used as a base for technology, such as microwave Internet and cellular telephone transmission. (ACDS, but originally from Kuna Library.)

In 1915, Kuna Village was incorporated to provide a better water supply for village residents. With the village incorporated, it could be bonded for sufficient funds to provide a water system. A 400-foot-deep well was dug, and a 40,000-gallon steel supply tank (pictured) was erected. Until the water system was put in, each house had a cistern that stored irrigation water and filtered it for household use. The Electric Investment Company granted a franchise, and a high-tension electric transmission line was built into Kuna to provide the city with power for pumping water. This meant that streetlights could be erected and that Kuna citizens had electricity for functions such as cooking and lighting. For many years, the water tower was located next door to the town's blacksmithing shop, and even today, the building next door is home to a machinist's shop. (Kuna Library.)

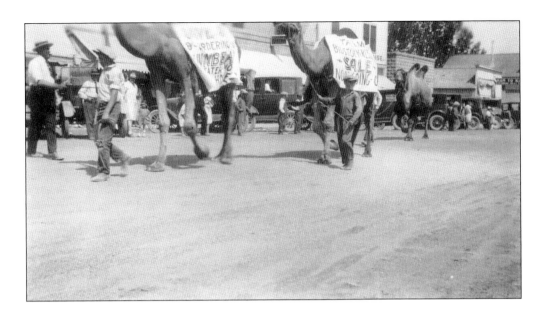

In 1918, and for the next five or six summers, Kuna hosted circuit Chautauquas, traveling educational/variety shows named after the town of Chautauqua in upstate New York with singers, lecturers, and other performers. The purpose was to bring culture to the Wild West. A big tent was set up with new entertainment each night of the week. Kuna merchants, churches, and residents subscribed to provide the upfront money necessary to procure it. Kuna was the only place in the valley to host the Chautauqua, and people came from Boise, Nampa, Meridian, and other towns—sometimes traveling for days—to participate. (Both, Kuna Library.)

In 1920, the Ellison White Chautauqua advertised for five days, from June 22 to 26. The Ellison White Lyceum course included vocal/instrumental music, readings, lectures, and short sketch plays. A committee was organized May 21, 1920, and included Bernard Matthews, Clarence Biggs, and Henry Sims. It was unusual for a community to work together in this way in order to make the Chautauqua free to attendees. (Both, Kuna Library.)

Like many other towns and cities in Idaho, Kuna has an annual festival each summer. Originally known as Kuna Fun Days, it is now typically referred to as Kuna Days, perhaps to differentiate it from Eagle Fun Days in the nearby city of Eagle. In 1964, Kuna celebrated its centennial, based on the founding of Fifteen Mile Station. At the time, Kuna Days was held in mid-August; more recently, the festival was moved to the first weekend of August. However, the barbecue put on by the city's fire department and promoted in the banner seen above still goes on. (Both, *Idaho Statesman* morgue in BSULSC.)

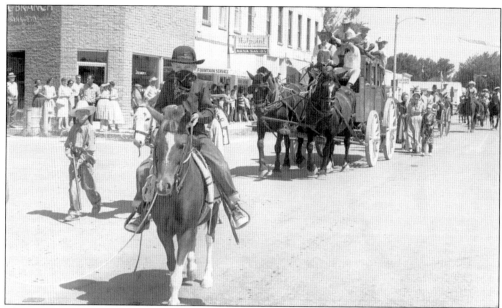

These pictures from August 1964 give a good look at Kuna's downtown, showing how little it had changed in more than 50 years. The Kuna Mercantile Building, in which the store was still located at that point, is still there, with its cloth awnings, which were taken down by the mid-1970s and have now been replaced with permanent awnings. Also visible is the bank on the corner, showing the stone facade added to the building that covered up its original structure. People in the photographs wear period costumes and use old-fashioned conveyances like horses, wagons, and bicycles. As is still the case, the Kuna Days parade includes a number of floats featuring town businesses, such as the Kuna television and radio repair shop in the picture below. (Both, *Idaho Statesman* morgue in BSULSC.)

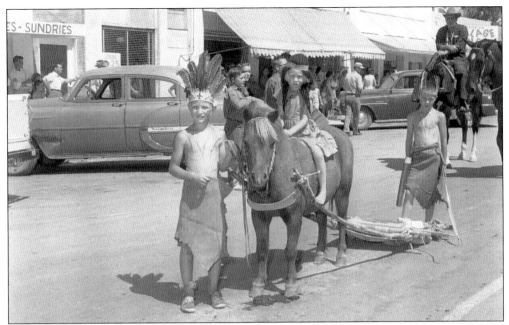

The pictures also show Kuna with diagonal parking, which changed to parallel parking later. These pictures show opposite sides of Main Street. The two-story building now known as the Arlene is visible; to its left is the Kuna Theatre, now a secondhand store. To its right is Kuna Hardware, still a hardware store today. The lumberyard at the right side of the picture has been torn down, and the site now holds the Kuna US Bank branch. (Photograph from the *Idaho Statesman* morgue in BSULSC.)

This picture from August 20, 1977, is from the Kuna Fun Days event. Scheduled as it is during what are typically among the hottest days of the summer, Kuna Days, as well as Eagle Fun Days, often features members of the city fire department staff using their firefighting equipment to cool down the crowds. As is apparent from the water tower overseeing the proceedings, this picture was taken on Main Street in front of what is now called Col. Bernard Fisher Veterans Memorial Park, after Kuna's Vietnam War hero and the first living Air Force Medal of Honor recipient. However, most residents simply refer to it as the city park. This picture was taken before a fence was built surrounding the park. (*Idaho Statesman* morgue in BSULSC.)

For a number of years, the community of Kuna, like many towns, featured a brass marching band of volunteers, typically made up of local businessmen, who performed at various events. The picture above is of the band practicing; the picture below, which later was used in a picture postcard, shows the band in a more formal pose. The photograph was taken in 1914. In 1932, the Improvement Club purchased two lots for $50 to be used as a site for the bandstand at the present city park. The bandstand was purchased from the Kuna City Band and moved to its present site. It was presented to and accepted by the city in September 1933. (Both, Kuna Library.)

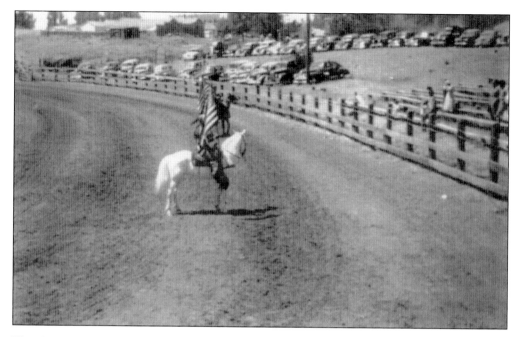

The Kuna Kave Riding Club (again using the "K" alliteration) was formed in 1948. It celebrated its 50th anniversary in 1998. The club sponsored events such as rodeos in its own arena, located near Indian Creek, which included parking and bleacher seats. These photographs show the grand entry to one of the rodeos, which lasted three days in 1952. The south fence in the photograph below is located along Indian Creek. Though it gave up the arena and track, and the clubhouse located in the park was torn down in 2000, the organization still meets. (Both, Barbara Daniel.)

The Kuna Kave Riding Club also marched in local parades, as shown here. Note that this parade is on Main Street in Kuna in front of the Arlene Building and what is now Kuna Hardware. In the mid-1950s, some meetings were held in the school because the organization was outgrowing its clubhouse. (Barbara Daniel.)

In addition to its arena, shown here near Swan Falls Road and the north side of Indian Creek, the club also built a clubhouse, raising money for it by sponsoring dances, as well as a racetrack, located near the Kuna Grange Hall (the present-day site of the baseball fields), where it held chariot races. (Barbara Daniel.)

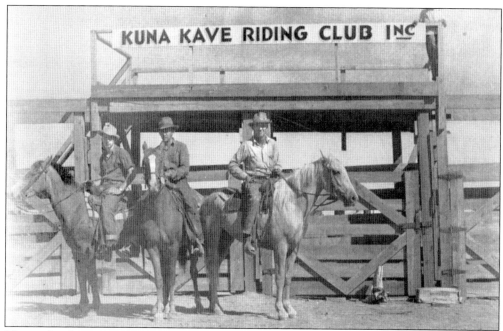

This undated picture, which appears in a December 1998 *Kuna Melba News* in a series of articles celebrating the group's 50th anniversary, is captioned "L/R: Ben Reynolds on Molly, Elmer Tucker on Blaze, and Don Reynolds on the palomino take a photograph break along with Dale Reynolds watching the activity from above the chutes." (Barbara Daniel.)

The Kuna Kave Riding Club also held trail rides for many years, visiting such sites as a gravel pit south of town or Kuna Cave. The group would also load up the horses and go for trail rides in more distant locations, such as the Snake River or the Owyhee Mountains. With 26 members, this trail ride was on September 17, 1978, at Black Creek Canyon. (Barbara Daniel.)

BIBLIOGRAPHY

Ada County Historic Preservation Council. "A Walking Tour of Kuna's Beginnings." http://www. adaweb.net/HistoricPreservationCouncil/Documents.aspx.

———"Preservation Plan for Cultural and Historic Resources." http://www.adaweb.net/ HistoricPreservationCouncil/Documents.aspx.

Barker, Rocky. "Morley Nelson Gets Name on Area He Helped Protect." *Idaho Statesman* 26 Mar. 2009.

Beitia, Sarah. "Morley Nelson: The Raptor World Loses a Great Friend." *Boise Weekly* 2 Mar. 2005.

Crow, Donna Fletcher. *Elizabeth: Days of Loss and Hope.* Carmel, NY: Guideposts, 1993.

———. *Kathryn: Days of Struggle and Triumph.* Carmel, NY: Guideposts, 1992.

———. *Stephanie: Days of Turmoil and Victory.* Carmel, NY: Guideposts, 1993.

Fick, Spencer Druss. *Patterns of the Past: The Ada County Historic Site Inventory.* Boise: Arrowrock Group, 2001.

Fisher, Sharon. "Behind the Gates at Swan Falls Dam." *New West* 22 May 2008.

———. "Kuna – Spotlight City." *Idaho* Dec. 2010.

Fisher, Sharon, Laura Rea, Ben Aylsworth, E.G. May, B. Mathews, Lois Dustman, Ruth Burningham, Wayne Kuhlman, Blanche Kuhlman, and Florence Chaney. "A History of the Kuna Grange." Unpublished manuscript, 2005. Microsoft Word file.

Hall, Jory. "Thumbprints Across the Pages of History – Kuna: Civil War to Chautauqua." 1997. Kuna Library.

Kuna Joint School District No. 3. *The Settlement of the Kuna Region 1900–1925.* Caldwell, ID: Caxton Printers, 1983.

Malone, Steve, for Ada County Development Services. "A Brief History of the Kuna Area." http:// www.adaweb.net/HistoricPreservationCouncil/Documents.aspx.

———. "Ada County Chronicles: An Overview of the Development of Ada County." http://www. adaweb.net/HistoricPreservationCouncil/Documents.aspx.

Rutan, Doug. "History of the Kuna School District." Unpublished manuscript, 2002. Microsoft PowerPoint file.

Discover Thousands of Local History Books
Featuring Millions of Vintage Images

Arcadia Publishing, the leading local history publisher in the United States, is committed to making history accessible and meaningful through publishing books that celebrate and preserve the heritage of America's people and places.

Find more books like this at
www.arcadiapublishing.com

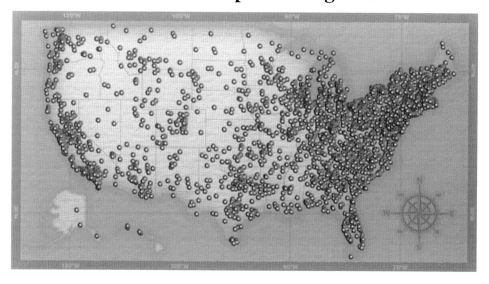

Search for your hometown history, your old stomping grounds, and even your favorite sports team.

Consistent with our mission to preserve history on a local level, this book was printed in South Carolina on American-made paper and manufactured entirely in the United States. Products carrying the accredited Forest Stewardship Council (FSC) label are printed on 100 percent FSC-certified paper.

MADE IN THE
USA